MERRY CHRISTMAS
JACK 2014

LOTS O
GRAMMY and POPPA
xoxo

D0131076

MARVEL

THE WORLD ACCORDING TO
SPIDER-MAN

WRITTEN BY **DANIEL WALLACE**
ILLUSTRATED BY **MIRCO PIERFEDERICI**

INSIGHT EDITIONS

San Rafael, California

CONTENTS

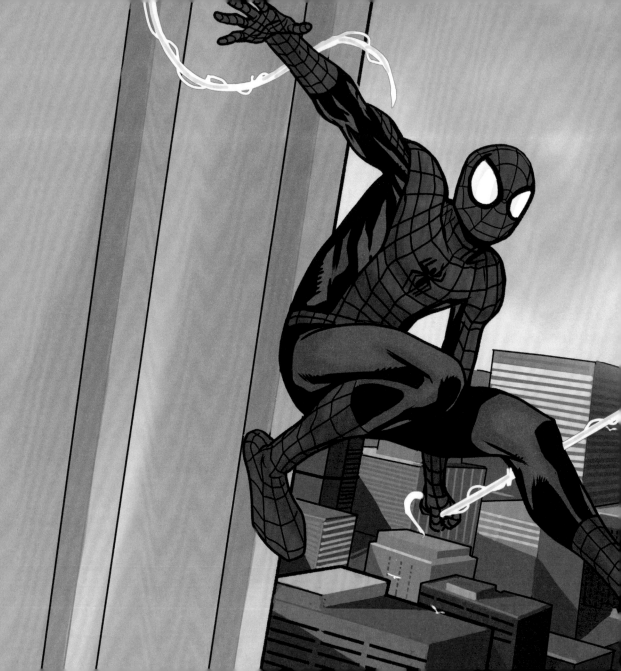

INTRODUCTION

SO, YOU WANT TO KNOW ABOUT BECOMING A SUPER HERO.
I mean, that's why you picked up this book, right? I happen to know quite a bit about theoretical physics, but nobody seems interested in that. Not to mention learning the secret behind Scorcher's Revenge, my award-winning five-alarm chili. (It's chopped cactus leaves. There, now you don't have to buy my recipe book, too. You're welcome!)

You've come to the right place for advice on Super Heroing, friend. Or, as I like to call it, Crime-Fighting While Wearing Tights. I started from nothing, and while my boss thinks I'm *less* than nothing, my aunt thinks I'm just swell! And you can be, too!

Being a Super Hero like me isn't only about a great costume and a set of flashy powers. It's about attitude and pizzazz, and I've got them in spades. You didn't pick up *Daredevil's Guide to Life*, did you? I don't blame you! (Also, don't tell him I said that.)

Your ol' pal Spidey has got you covered. I'll teach you how to develop an approach to crime-fighting that'll make people like you. And also, how to ignore the negative press you'll attract no matter what. The *Bugle* will print anything these days, am I right?

I'll explain the right way to build up your personal rogues' gallery of Super Villains and how to fight so you don't completely humiliate yourself on your first outing. That would make *me* look bad, so stay focused, rookie!

And because I like you—you've got a sympathetic face; it must be the eyes—I'm going to open up on the topic of secret identities. We heroes are a close-knit bunch, and if I'm going to welcome you to the family, that means I have to try to prevent you from making some of the same mistakes I made. And if I get too busy to finish this thing, I'll just farm the remaining work out to guest stars.

Do you want to follow in my red-booted footsteps and become a true hero? No? You just want to drool over the Spider-Mobile? I don't blame you, that's one sweet ride!

Either way, read on! And pay attention—**THERE WILL BE A TEST!**

History of Spider-Man:
HOW A ZERO BECAME A HERO

IF YOU'RE HOPING TO be a Super Hero like me, you need an origin story. So here's one of the best!

PETER PARKER, BOY GENIUS, GREW UP IN THE CARE OF HIS AUNT MAY AND UNCLE BEN.

IGNORED AND UNAPPRECIATED, PETER GOT TOO CLOSE TO A RADIOACTIVE SPIDER ON A CLASS FIELD TRIP.

HE DISCOVERED HE COULD CLING TO WALLS AND PERFORM GREAT FEATS OF AGILITY AND STRENGTH!

BUT WHEN HE FAILED TO STOP A ROBBER, THE CROOK TOOK UNCLE BEN'S LIFE. PETER LEARNED THAT WITH GREAT POWER COMES GREAT RESPONSIBILITY.

INSPIRED BY HIS SPIDERY GIFTS, PETER BUILT MECHANICAL WEB-SHOOTERS.

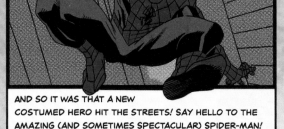

AND SO IT WAS THAT A NEW COSTUMED HERO HIT THE STREETS! SAY HELLO TO THE AMAZING (AND SOMETIMES SPECTACULAR) SPIDER-MAN!

NOT EVERYBODY WAS A FAN. TAKE J. JONAH JAMESON, PUBLISHER OF THE *DAILY BUGLE*. (NO, SERIOUSLY, TAKE HIM FAR AWAY. THANKS.)

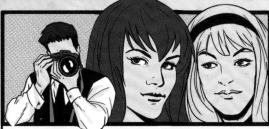

PETER FOUND WORK AT THE *BUGLE* AS A PHOTOGRAPHER. HE GOT LUCKY IN LOVE . . .

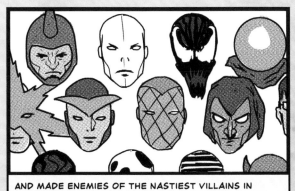

AND MADE ENEMIES OF THE NASTIEST VILLAINS IN NEW YORK . . .

BUT THE WEB-SWINGIN', WALL-CRAWLIN' SPIDEY CAME OUT ON TOP!

DID YOU ENJOY THAT COMIC? GREAT, THAT'LL BE $3.99. THIS AIN'T A LENDING LIBRARY, PAL.

COSTUME CARE

AH, THE OLD RED-AND-BLUE!
It's one of the all-time iconic Super Hero designs, and I sewed it in my bedroom!

You'll probably have to make your own, too, since they don't just sell 'em off the rack at Macy's. Hopefully, you've got mad home-ec skillz like me!

I've been adventuring in this costume for years, so here's what you need to remember when creating your own design:

CHOOSE BOLD, BRIGHT COLORS. YOU WANT YOUR COSTUME TO LOOK GOOD IN THE COMIC BOOK THEY'LL EVENTUALLY MAKE ABOUT YOUR ADVENTURES.

A BIG LOGO, CENTERED ON YOUR CHEST. DON'T COPY SOMETHING YOU FOUND ON THE INTERNET! TRADEMARK LAWYERS ARE WORSE THAN MOLE MEN.

BREATHABLE FABRIC. YOU'RE GONNA SWEAT A LOT.

MAKE IT EXTRA STRETCHY IN THE GROIN AREA. DON'T SPLIT YOUR PANTS.

ZIPPERS, FLAPS, BUTTONS, VELCRO, BRASS SNAPS—I DON'T CARE. BUT LEAVE YOURSELF SOME WAY TO GO TO THE BATHROOM!*

MAKE SURE THE COSTUME IS TIGHT ENOUGH TO KEEP EVERYTHING IN PLACE. NOTHING SHOULD DANGLE OR JIGGLE. A LITTLE BODY-SHAPING IS OK WHEN YOU'RE A SUPER HERO.

KEEP IT THIN ENOUGH TO WEAR UNDER YOUR STREET CLOTHES. THIS IS IMPORTANT FOR KEEPING A SECRET IDENTITY. I'LL COME BACK TO THIS LATER.

*YOU WILL ONLY MAKE THIS MISTAKE ONCE, BTW.

IT'S CLOTH, NOT KEVLAR!

Battle damage looks gritty, but seriously, how are you going to fix that?

LAUNDRY CARE

Wash your costume separately on the cold cycle and always air dry. Also, check to make sure you didn't accidentally put a webbing cartridge in with the load.

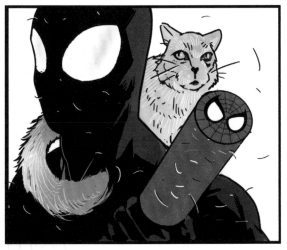

GOT A DARK COSTUME? GOT A CAT?

Consider hero-branded lint rollers!

BEWARE "COWL HEAD"!

When you wear a mask like mine, every day is a bad hair day.

COSTUME VARIANTS: KEEPING IT FRESH

I MOSTLY STICK TO my classic threads. I'm not like Iron Man—that guy makes so many costumes he even built *me* one. But once in a while you need to bust out something new.

Don't worry, it's usually just for a special event! Here's a few variants to give you the general idea. Just don't go stealing my style!

IRON SPIDER

Like I said, Tony Stark gave it to me. It would have been rude *not* to take it. Incorporates a targeting computer and self-repairing nanotech armor. Hey, you try affording something like this on a freelancer's salary!

BEST FEATURE: These three giant arms that come out of the back. Great for scratching your nose while carrying a big tray of donuts.

WHY I DUMPED IT: Saw my picture on Buzzfeed captioned, "What if Iron Man and Doctor Octopus had a baby together?"

MERCHANDISING

So this merchandising company wanted me to rotate between different colored costumes. "It's easy to make toys out of them," they told me. "Come on, Spidey, it's just a palette swap." No way, I said. I turned 'em down flat. You should have offered me a percentage of gross revenues, not net, fellas!

BACK IN BLACK

I know this is an oddly specific warning, but try not to wear costumes that are secretly alien organisms from deep space, mmmkay?

BEST FEATURE: I didn't have to put it on or take it off! It just kind of . . . morphed. Made its own webbing, too.

WHY I DUMPED IT: It turned into this guy:

STEALTH SUIT

Bends light around itself to become nearly invisible. Muffles noises for silent running. Requires batteries, but just those really small AAA ones.

BEST FEATURE: Lets you sneak up on Wolverine! (WARNING: Do not whisper "Boo!" in his ear.)

WHY I DUMPED IT: Does that design say "Spider-Man" to you? Or does it say "rogue program who escaped the computer world in search of glow sticks"?

13

REJECTED COSTUMES

THEY CAN'T ALL BE GEMS! Chances are you're going to churn out some bad designs on your way to a winner. Just take a peek at my sketchbook.

AMBLIN' ARACHNID

SPECIAL QUALITIES: Ability to sense whether latte is half-caf or full caf
EQUIPMENT: Medicated insoles

EL ARAÑA FURIOSO

SPECIAL QUALITIES: Flying drop kick
EQUIPMENT: Sweaty luchador mask

SPŸDER MÄN

SPECIAL QUALITIES: Shreds face-melting solos on double-necked Flying V
EQUIPMENT: Exploding guitar picks

X-TREME X-PIDER

SPECIAL QUALITIES: Incomprehensible backstory

EQUIPMENT: Pouches. So many pouches.

SPOOOOKY SPIDER

SPECIAL QUALITIES: Last-minute resourcefulness

EQUIPMENT: Costume assembled for less than ten bucks at the dollar store

ITSY BITSY

SPECIAL QUALITIES: Repels the rain that washes the spider out

EQUIPMENT: Water-resistant windproof jacket

EMOTING WITH YOUR MASK

A MASK IS GOOD for keeping your secret identity a secret, but does it make you an emotionless blank slate? No way! In fact, with a mask you can communicate better than ever before! What's the secret? **Giant white eyes.** Here's some tips! (Special thanks to Empire State University for the drama class I took for fill-in credits.)

SURPRISE

Open your eyes as wide as they'll go. The fabric expands. See?

SUSPICION

You don't believe that guy, do you? Give him the squint. "I know you've got fives, don't be telling me to Go Fish!"

SKEPTICISM

Arch one eyebrow. Stretch that fabric! (Can also be used to convey cockiness on movie posters.)

SLEEPINESS

Both eyes down— half-lidded, not squinty. Good thing your mask is so expressive, huh?

THE BLISSFUL LOTUS

Tilt your head back toward the puffy clouds. Breathe in through your mouth and out through your nose. Relaxing, isn't it?

THE HYPNO-TOON

(Advanced Users Only). How else are you going to let people know you've gone a little cuckoo?

THE EAR PROBLEM

"My best feature is my ears" is a phrase that's been uttered exactly zero times. I'm not crazy about my ears either, so when it comes to my costume I just vanish 'em.*

What? I tried the alternative once and it was ridiculous!

*THIS WORKS FOR YOUR NOSE TOO. GOOD THING CARTILAGE IS SO FLEXIBLE!

WEB-SHOOTERS

"HOW DO THEY WORK?" you're wondering. "Why can't I invent a revolutionary new polymer and the miniaturized equipment needed to fire it?" you're wondering.

Regarding the second question, I won a lot of science fairs. And, to address the first, I'm always happy to explain the wonders of web-shooters!

So anyway, you know how I built those web-shooters? The next thing I know I get a secondary mutation—spider spinnerets growing right out of my wrists! Crazy, right?

Then the spinnerets went away again, but I made this comparison chart to the right for the next time it happens.

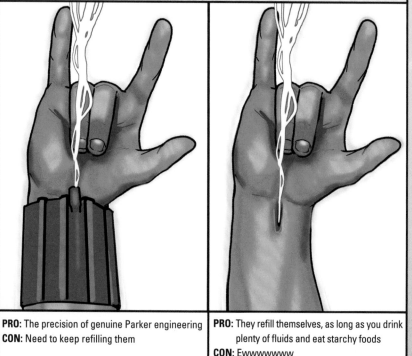

MECHANICAL WEB-SHOOTERS VS. ORGANIC WEB-SHOOTERS

PRO: The precision of genuine Parker engineering
CON: Need to keep refilling them

PRO: They refill themselves, as long as you drink plenty of fluids and eat starchy foods
CON: Ewwwwwwww

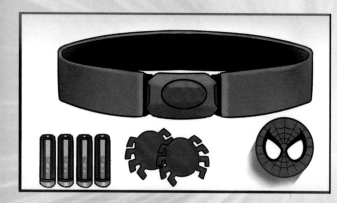

UTILITY BELT

Yeah, I wear this sometimes. It's slim-fitting!
- The belt mostly carries spare web cartridges.
- Also spider-tracers (electric bugs I stick on people to track them from a distance).
- And the buckle is a flashlight! In the shape of my face! Which I can project onto the sides of buildings or . . . y'know, it sounded way cooler when I built it, so let's just drop the subject.

WEB-SHOOTER MARK 2.0: THE SPIDEY SPECIAL

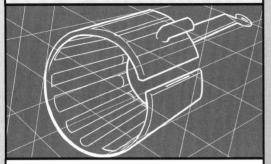

- Elastic wristband
- Pressurized web fluid cartridges
- Motorized carousel to rotate cartridges into firing position
- Sealed battery compartment
- Threaded nozzle
- Spring-steel palm trigger
- Teflon-coated turbine pump
- Adjustable openings
- Internal release valve widens and narrows under trigger pressure
- Webbing solidifies on contact with air
- Release trigger cuts off web line

SHOOTING MODES

The web-shooters fire a special synthetic adhesive with a tensile strength of 120 pounds per square millimeter.

NARROW LINE

WIDE SPRAY

GOOEY GLOB

HOLIDAY MAGIC (DECEMBER ONLY)

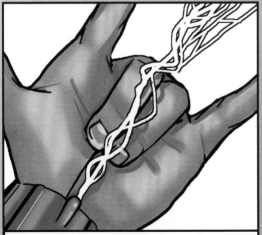

FIRING THEM IS EASY. JUST DOUBLE-TAP THE TRIGGER, USING YOUR MIDDLE TWO FINGERS ONLY.

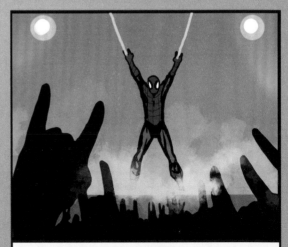

IF YOU HAVE TROUBLE REMEMBERING, JUST PRETEND YOU'RE HEADLINING A HEAVY METAL REUNION TOUR!

WEB-SWINGING LIKE A PRO

YOU CAN DO A lot with a web line. But what you'll probably do the most of, especially in NYC, is web-swinging. Cheaper than a cab, less smelly than the subway, and you never have to pay for parking. What could be better?

Even if you don't use webbing in your crime-fighting career, you might use grappling hooks or hero-rangs or something similar. It's the same principle!

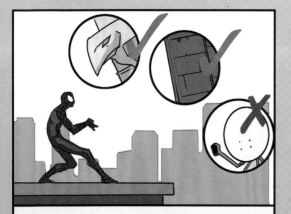

STEP 1: FIND YOUR ANCHOR POINT. BRICK COLUMN, STONE GARGOYLE, FIRE ESCAPE = GOOD. HANGING PLANT, SATELLITE DISH, PIGEON COOP = BAD.

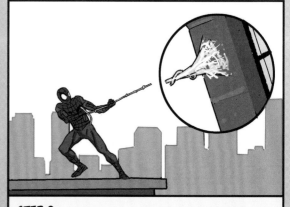

STEP 2: FIRE! MY WEB LINES CAN TRAVEL 100 FEET EASILY. GIVE THE LINE A TUG TO MAKE SURE IT'S SECURE.

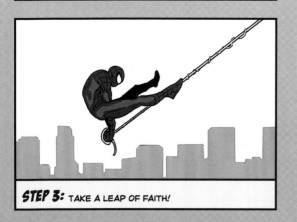

STEP 3: TAKE A LEAP OF FAITH!

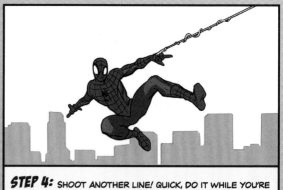

STEP 4: SHOOT ANOTHER LINE! QUICK, DO IT WHILE YOU'RE IN MID-SWING! YOU DON'T WANT TO LOSE MOMENTUM!

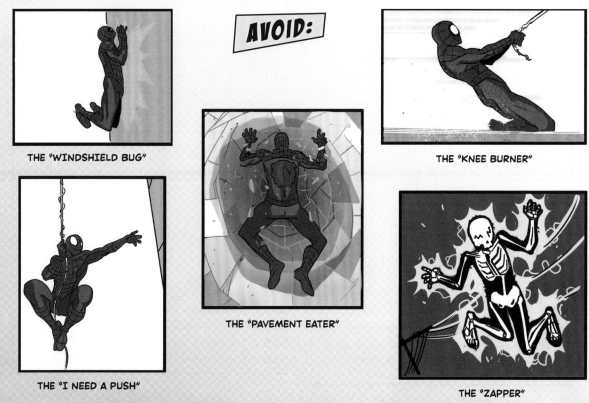

AVOID:

THE "WINDSHIELD BUG"

THE "PAVEMENT EATER"

THE "KNEE BURNER"

THE "I NEED A PUSH"

THE "ZAPPER"

THE WEB LINES DISSOLVE AFTER AN HOUR, BUT NOT EVERYBODY'S HAPPY WHEN I SWING THROUGH THEIR NEIGHBORHOOD.

WEB FLUID:
IS THERE ANYTHING IT CAN'T DO?

WHY DID I INVENT this amazingly sticky, spectacularly strong polymer? Because every spider needs a web! (Well, except for *Haplopelma huwenum* and the other members of the Theraphosidae family, but you knew that already.)

I already showed you how webbing can be used for rapid transit, but it also comes in handy for blinding crooks, tying them up, and cutting off the escape routes of their getaway cars.

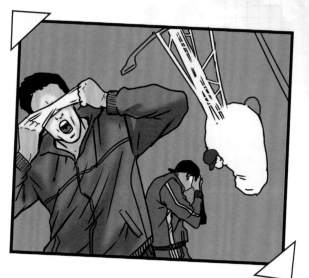

OTHER SPIDER-SPECIFIC ACTIVITIES:

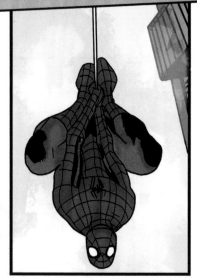

DANGLING
Hanging upside down from the end of a web line; really creeps people out.

BALLOONING
Wafting through the air on a billowy tuft of spider silk—wheee!

SPELLING THINGS
Wait, that wasn't a true story?

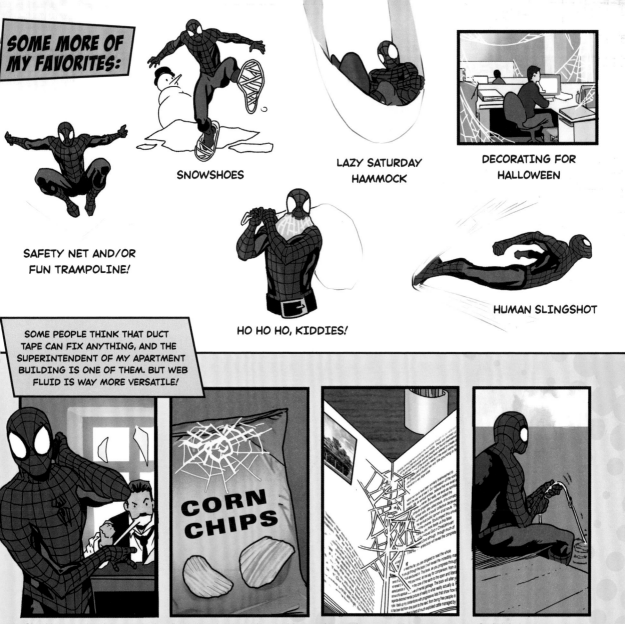

SOME MORE OF MY FAVORITES:

SNOWSHOES

LAZY SATURDAY HAMMOCK

DECORATING FOR HALLOWEEN

SAFETY NET AND/OR FUN TRAMPOLINE!

HO HO HO, KIDDIES!

HUMAN SLINGSHOT

SOME PEOPLE THINK THAT DUCT TAPE CAN FIX ANYTHING, AND THE SUPERINTENDENT OF MY APARTMENT BUILDING IS ONE OF THEM. BUT WEB FLUID IS WAY MORE VERSATILE!

CORN CHIPS

Shushing people when you're on the phone

Resealing that bag of corn chips

No stapler, no problem

Catfish bait

23

WALL-CRAWLING

BOY, THE PRICE OF gas these days. It's enough to drive you up the wall!

Ah, I slay myself. Wall-crawling is one of my signature powers, and it's why I call myself Spider-Man and not Arthropod-Man or Radioactive Bite-Man.

I can scuttle across the ceiling or just hang out on the side of a skyscraper like it ain't no thang. Luckily it works through the fabric of my gloves or any thin layer of clothing.

WHAT'S THE SECRET?
DR. CONNORS SAYS:
"MICROSCOPIC BARBED HAIRS, OR SCOPULAE, INCREASE ADHESION VIA ATOMIC STATIC CLING. THIS ATTRACTIVE FORCE INCREASES THE LOCAL COEFFICIENT OF FRICTION."

This power doesn't work through shoes, so I guess I dodged that fashion bullet.

I don't just cling to walls, I can cling to anything. Like snagging a line drive to right. Don't even need a baseball glove!

SPIDER-STICKINESS:
IT ISN'T JUST FOR FINGERTIPS ANYMORE!

ARMS

BACK

FEET

BUTT

25

ARE YOU STRONG? LISTEN, BUD!

STRENGTH! IT'S GREAT IF YOU'VE GOT IT . . . and brother, I can juggle cars!
Not those two-seater clown commuters, either. I'm talking real Detroit steel.

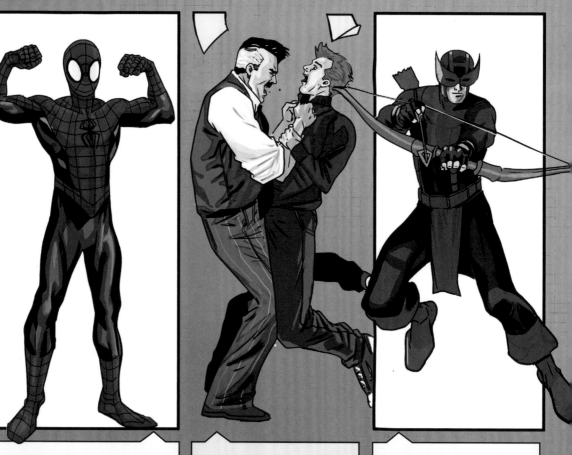

SPIDER-MAN
I put all of the other guys on this page to shame.* Not bad for the proportionate strength of a spider!

STRENGTH RATING: 20 tons

J. JONAH JAMESON
Able to hoist an intern by the shirt collar.

STRENGTH RATING: 98 lbs.

HAWKEYE
Longbow has a draw weight of 125 lbs., and he really shoots a lot of arrows.

STRENGTH RATING: 315 lbs.

CAPTAIN AMERICA
Does reps using shattered monuments to fascism.

STRENGTH RATING: 1,200 lbs.

JUGGERNAUT
Nothing can stop him, not even the blast doors at NORAD.

STRENGTH RATING: 1,500 tons

THE HULK
He once held up a mountain. Literally, a mountain.

STRENGTH RATING: 150,000,000 tons

*OKAY, SO I'M NOT THE STRONGEST. THAT'D BE THESE GUYS. THERE'S A LESSON HERE ABOUT OVERCONFIDENCE, SO LET'S PRETEND I JUST TAUGHT YOU THAT.

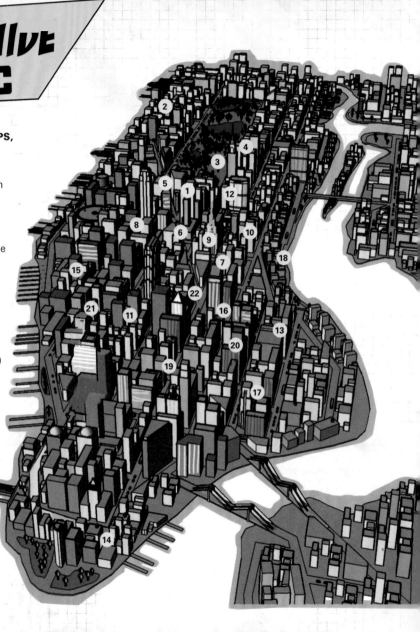

Sr IVEY'S GUIDE TO NYC

IT'S THE CITY THAT NEVER SLEEPS,
which means I never get a break!
Luckily I'm not the only hero in this
town, but things are never easy when
New York is a magnet for weirdness.

Galactus targets the planet Earth
for annihilation? The guy lands in
Midtown. Atlantis attacks the surface
world? Fish dudes in Battery Park.
Skrulls drop an alien army? Times-
freaking-Square.

Sometimes you just wanna say,
where can a guy get a decent kebab
in this town? (At 52nd and 7th, but
don't let the whole world know, geez.)

1. How do you get to **CARNEGIE HALL**?
 You walk, or take a cab. No jokes
 today. I haven't had my coffee yet.

2. **MARY JANE'S** Upper West Side
 apartment is a bit bigger than
 my own.

3. **CENTRAL PARK ZOO.** If I were
 Kraven the Hunter, I'd sleep
 here every night.

4. **AVENGERS MANSION**. If you get
 past the security systems, tell Jarvis
 I said "hi."

5. **STARK TOWER** is at 58th and
 Broadway. I keep peeking in the
 windows, but Tony's never home.

6. You can get your picture taken with **SPIDER-MAN** in Times Square. Pro tip: IT'S NOT ACTUALLY SPIDER-MAN.

7. Bootleg **SPIDER-MERCH** sold here!

8. **HELL'S KITCHEN**. Daredevil patrols this area. And on Saturdays you can go street antiquing!

9. The **EMPIRE STATE BUILDING** offers the best views of the city. Good enough for King Kong, good enough for Spidey.

10. The **CHRYSLER BUILDING**. Use the mirrored gargoyles to adjust your mask.

11. **DOCTOR STRANGE'S** house is here in Greenwich Village. Excuse me, his "Sanctum Sanctorum."

12. **BAXTER BUILDING**. Home of the Fantastic Four. Occasionally gets launched into space.

13. This place used to sell that **IMPORTED LICORICE** until they stopped making it two years ago.

14. **HORIZON LABS** in the South Street Seaport. The researchers here built a time portal that I used to travel two years into the past and buy up all that imported licorice.

15. You can get a great slice of **PIZZA** here, and they let me run a tab. It's not like I carry money in this suit!

16. The **DAILY BUGLE** building. Hi ho, hi ho, it's off to submit a freelancer's invoice I go!

17. **MY APARTMENT'S** around here. Everything looks different from the air.

18. One of **ICEMAN'S** ice slides. These things take days to melt.

19. Here's **STILT-MAN.** This guy's really bad at hiding.

20. My alma mater, **EMPIRE STATE UNIVERSITY**! They had a couple Super Villains on staff.

21. The **HYPNO-HUSTLER'S** playing at a club here next Saturday.

22. Just try getting a taxi when it's raining. **WEB-SWINGING** all the way, baby.

OUTSIDE MANHATTAN

- The Human Torch likes to meet up with me at the **STATUE OF LIBERTY**, but I skedaddle when I see him coming. Nah, I'm kidding. We kid each other.

- **CONEY ISLAND AMUSEMENT PARK**. Think I fought Doc Ock here? Barely remember, had terrible head cold.

- **FOREST HILLS, QUEENS**. Home of Midtown High School and my ever-loving Aunt May.

- Former site of **SHEA STADIUM**. I fought my own clone here—long story. (Seriously, it would take years and hundreds of issues.)

- **RYKER'S ISLAND** Maximum Security Installation is specifically designed to keep superpowered criminals behind bars. Naturally they break out every Tuesday.

BUILDING A *ROGUES' GALLERY*

SCORPION

The Scorpion is a henchman goon who henches for the highest bidder. His battlesuit has a built-in scorpion tail that can knock down walls.

THEMATIC FIT:
Did you know we're complementary animals? Scorpions and spiders are both eight-legged invertebrates and members of the class Arachnida. True fact.

DOCTOR OCTOPUS

Dr. Otto Octavius is an engineering genius whose four mechanical tentacles pack a powerful punch.

THEMATIC FIT:
Doc Ock is an inventor like me, but he uses his gifts for evil. Why you gotta go and give brainiacs a bad name, doc?

GREEN GOBLIN

After suffering a psychotic break, industrialist Norman Osborn unleashed mayhem with a flying goblin-glider and a bag full of gas grenades.

THEMATIC FIT:
He's a billionaire, while I'm practically penniless. Root for the underdog, kids!

THE LIZARD

Dr. Curt Connors conducted experimental research into the applications of reptile DNA, which, as you might expect, mutated him into the ravenous and bloodthirsty Lizard.

THEMATIC FIT:
The two of us are friends and fellow science geeks—but when Dr. Connors loses control, watch out! As they say on TV, he must learn to control the raging spirit that dwells within.

THEY SAY A HERO is only as good as his villains. I say nuts to that! I'm way better than these clowns. But if you're a rookie hero, you'll need to attract some recurring foes before the media will take you seriously. These enemies need to be heavy hitters, but they also need to fit your heroing theme! They could be your spiritual opposites or your dark-mirror doppelgangers—that sort of thing. Here, I'll show you what I mean.

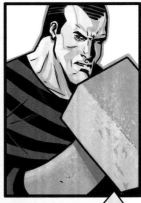

KRAVEN THE HUNTER

A big-game hunter and expert tracker, Kraven is always spoiling for a fight. Especially when I make fun of his lion-face vest!

THEMATIC FIT:
Kraven represents the conflict of brawn vs. brains. See, folks, sometimes punching is the answer!

THE VULTURE

I've got to hand it to this guy—he's nearly as old as my Aunt May, but he uses his vulture wings to fly around New York City robbing banks. I hope I'm half as spry when I reach retirement age.

THEMATIC FIT:
He's a bird, I'm a spider; he's the predator, I'm the prey. It's the circle of liiiiiiife . . .

MYSTERIO

Mysterio is a former special-effects artist whose costume is basically an inverted fishbowl. He spins illusions and surrounds himself with a gloomy fog wherever he goes. Such a drama magnet!

THEMATIC FIT:
The intangible opponents Mysterio creates are the stuff of hallucinations and nightmares, and are battled in the realm of the mind. Which is lucky for Mysterio because he's a crummy fighter.

THE SANDMAN

Because he's made of sand, ol' Sandy can shapeshift into brick walls, giant hammers, or really gritty cyclones. Try not to get pieces of him in your sandwich, because that will ruin the picnic, full stop.

THEMATIC FIT:
He looks pretty cool, I guess? Photos of battles between the two of us always come out looking great.

THE VILLAIN HALL OF SHAME

WHY DO I ATTRACT so many third-tier villains? Am I too nice? Don't be as nice as me. It's like feeding a stray dog. You bust up one bank robbery, and they'll hang around in your rogues' gallery forever.

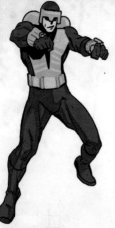

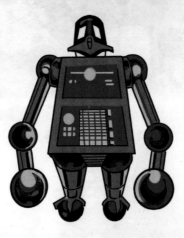

TRAPSTER

WHAT HE DOES: Shoots glue at people

WHY HE'S LAME: Used to call himself Paste-Pot Pete. Sure he's a decent chemist, but *Paste-Pot Pete,* c'mon!

LIVING BRAIN

WHAT IT DOES: State-of-the-art supercomputer—at least it was back when it visited my high school

WHY IT'S LAME: Got replaced by a Living Brain smartphone app

KANGAROO

WHAT HE DOES: Hops around in a Down Under battlesuit

WHY HE'S LAME: Battlesuit has a gun that's hidden inside a kangaroo pouch. Don't be a slave to your gimmick, people!

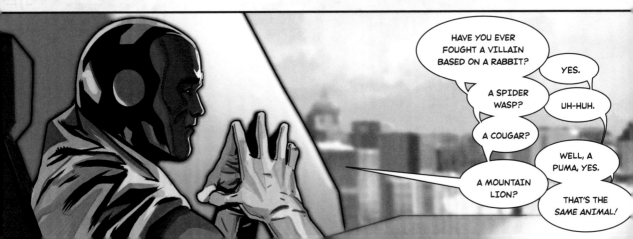

GIBBON

WHAT HE DOES: Enthusiastic ape-man who's kind of agile, I guess. Wants to be a hero; doesn't get that I'm not his coach.

WHY HE'S LAME: Won't stop texting me

GRIZZLY

WHAT HE DOES: Ex-wrestler and fur enthusiast

WHY HE'S LAME: Fond of grappling, not fond of personal hygiene

LEAP-FROG

WHAT HE DOES: Has springs in his flippers

WHY HE'S LAME: Has springs in his flippers

ANIMAL CRACKERS

Why do so many of my enemies have animal themes? I dunno, but here's a few animal ideas nobody's using yet. Entry-level villains, get on this! You might get a spot on the Sinister Six!

- Proboscis Monkey
- Naked Mole Rat
- Google-Eyed Bass
- The Punctual Pony
- Mechanical Flatworm
- Evil Axolotl
- Four-Toed Sloth (the fourth toe is Adamantium)

BAD GUY TAKEDOWNS

WHEN YOU'RE JUST STARTING OUT, every fight is an unknown. You're going to face villains and have no idea what to do next—but buck up, camper! You'll be fine as long as you target their weak points!

HAMMERHEAD

Mob boss crazy for Prohibition-era retro kitsch: Tommy guns, pinstripe suits, the Lindy Hop.

ABILITY:
Indestructible Adamantium skull

VULNERABILITY:
Knees, throat, solar plexus, ingrown toenail—basically any place on his body besides his skull

HYDRO-MAN

Like Sandman, only with water! It's not his fault that an experimental ocean generator gave him a derivative super power.

ABILITY:
Can turn his body into water

VULNERABILITY:
Wet/dry shop vacs, the process of evaporation

STILT-MAN

Inventor who created his own armored battlesuit. Iron Man he ain't.

ABILITY:
Telescoping stilts

VULNERABILITY:
Balance. Use your harpoons and tow cables—go for the legs!

SPIDER-SLAYER

Wall-crawling robot built by a mad scientist, programmed to kill me, and paid for by J. Jonah Jameson. Remind me why I work for this guy again?

ABILITY:
Destructo-beam

VULNERABILITY:
On/off switch or a self-destruct button. If it's built by a mad scientist, always look for the self-destruct! You'll thank me later.

THE ART OF *WITTY BANTER*

I'VE GOT A PHILOSOPHY on fighting: Keep things light. It puts the public at ease, seriously cheeses off your enemies, and lets you try out new material outside of Open Mic Night at the Laff Factory.
Take a look at these!

POLITICAL, BUT NOT TOO POLITICAL! EVERYBODY, EVEN STEGRON THE DINOSAUR MAN, GRIPES ABOUT THOSE BUMS IN WASHINGTON.

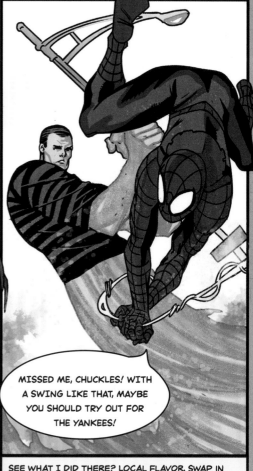

SEE WHAT I DID THERE? LOCAL FLAVOR. SWAP IN YOUR HOMETOWN BALL CLUB IF YOU WANT TO COPY THIS ONE FOR YOUR OWN USE.

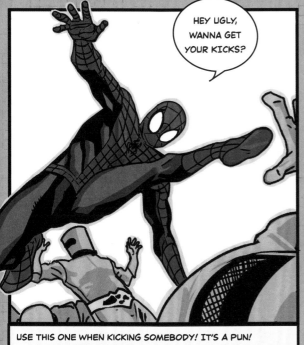

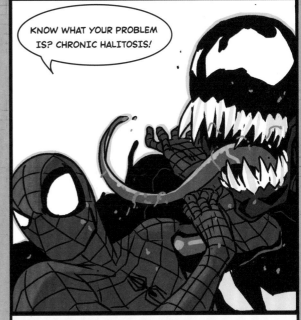

USE THIS ONE WHEN KICKING SOMEBODY! IT'S A PUN!
ALSO ACCEPTABLE: "WHADDYA THINK—WITH LEGS LIKE THESE,
SHOULD I JOIN THE ROCKETTES?"

THIS WILL INFURIATE YOUR OPPONENT (ASSUMING THEY
KNOW WHAT HALITOSIS MEANS) AND MAKE THEM DO
SOMETHING STUPID. IF THEY ACTUALLY TAKE THE HINT AND
BUY BREATH MINTS, THAT'S A BONUS!

BE APPROACHABLE!

HEY, YOU KNOW ME. I'M NOT THE MERCILESS SPIDER-MAN, OR THE UNPLEASANT
SPIDER-MAN. I'M YOUR FRIENDLY NEIGHBORHOOD SPIDER-MAN!

IT'S A SLOGAN.

LET ME BREAK
IT DOWN:

COURTESY OF
YOUR FRIENDLY
NEIGHBORHOOD
SPIDER-MAN

I'M NOT THE BAD
GUY! DON'T BELIEVE
EVERYTHING THEY
PRINT IN THE
PAPERS!

I'M LOCAL! DON'T
PATRONIZE THE BIG
CONGLOMERATES
FOR YOUR HEROING
NEEDS!

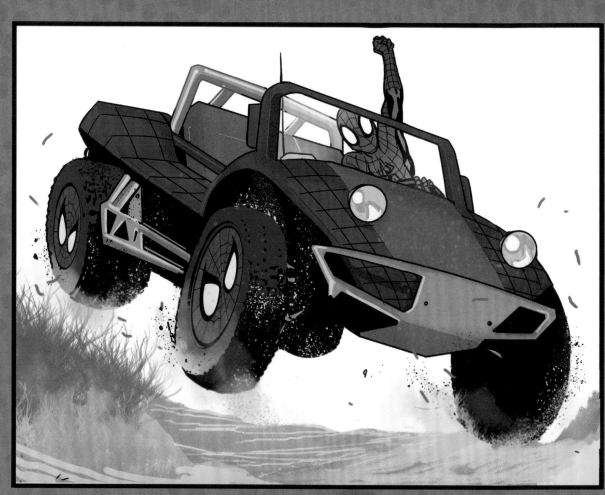

DO YOU NEED A CAR? OF COURSE YOU DO!

YOU KNOW WHY THEY CALL ME the Amazing Spider-Man? It's because I have a car, and I live in New York. Sure, maybe my ride is a little dated, but sometimes you just really need a dune buggy, y'know?

I got my wheels as part of an advertising stunt—but if you're a reclusive billionaire, feel free to build your own hero-mobile in an underground cave. If you're on a budget, just apply some aftermarket decals to whatever you're currently using to deliver pizzas!

CORONA MOTORS SPIDER-MOBILE

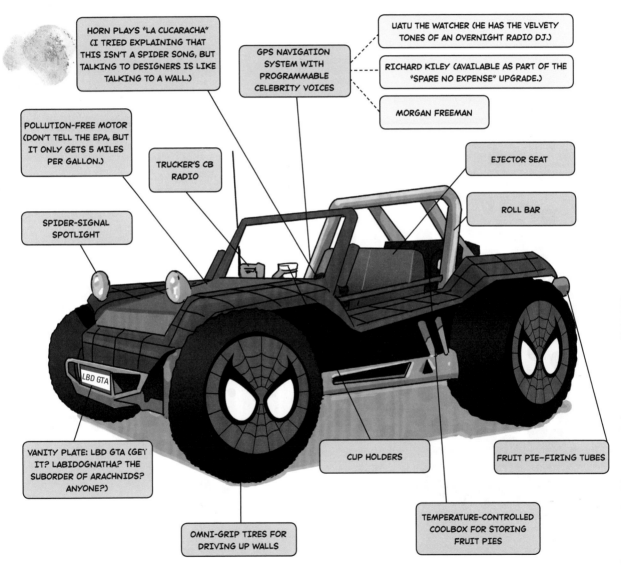

HORN PLAYS "LA CUCARACHA" (I TRIED EXPLAINING THAT THIS ISN'T A SPIDER SONG, BUT TALKING TO DESIGNERS IS LIKE TALKING TO A WALL.)

GPS NAVIGATION SYSTEM WITH PROGRAMMABLE CELEBRITY VOICES

UATU THE WATCHER (HE HAS THE VELVETY TONES OF AN OVERNIGHT RADIO DJ.)

RICHARD KILEY (AVAILABLE AS PART OF THE "SPARE NO EXPENSE" UPGRADE.)

MORGAN FREEMAN

POLLUTION-FREE MOTOR (DON'T TELL THE EPA, BUT IT ONLY GETS 5 MILES PER GALLON.)

TRUCKER'S CB RADIO

EJECTOR SEAT

ROLL BAR

SPIDER-SIGNAL SPOTLIGHT

VANITY PLATE: LBD GTA (GET IT? LABIDOGNATHA? THE SUBORDER OF ARACHNIDS? ANYONE?)

LBD GTA

CUP HOLDERS

FRUIT PIE–FIRING TUBES

OMNI-GRIP TIRES FOR DRIVING UP WALLS

TEMPERATURE-CONTROLLED COOLBOX FOR STORING FRUIT PIES

THE DOWNSIDE OF

THE LIFE OF A SUPER HERO isn't all team-ups and showdowns. Everyday headaches come with the territory, no matter what set of powers you've acquired.

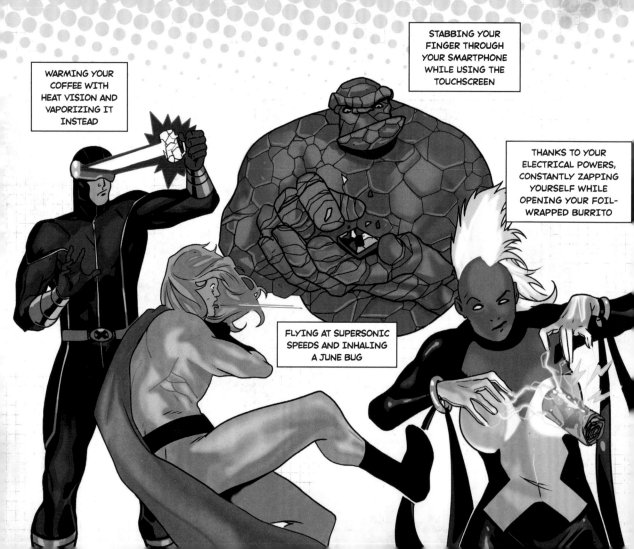

WARMING YOUR COFFEE WITH HEAT VISION AND VAPORIZING IT INSTEAD

STABBING YOUR FINGER THROUGH YOUR SMARTPHONE WHILE USING THE TOUCHSCREEN

THANKS TO YOUR ELECTRICAL POWERS, CONSTANTLY ZAPPING YOURSELF WHILE OPENING YOUR FOIL-WRAPPED BURRITO

FLYING AT SUPERSONIC SPEEDS AND INHALING A JUNE BUG

THINGS *SPIDER-SENSE* DOESN'T WARN YOU ABOUT

IT'S ONE OF MY LESSER-KNOWN POWERS, but my spider-sense alerts me to danger before it happens! It also makes wavy lines appear above my head. See? But spider-sense can't do everything.

FOR EXAMPLE, IT NEVER TELLS ME ...

WHETHER A MOVIE SEQUEL WILL LIVE UP TO THE PROMISE OF THE ORIGINAL, OR WHETHER IT'LL BE AN OVERSTUFFED MESS WITH TOO MANY VILLAINS AND SOME BAFFLING SCRIPT DECISIONS

WHEN IT'S TIME TO ROTATE THE TIRES ON THE SPIDER-MOBILE

THE CORRECT PRONUNCIATION OF WORCESTERSHIRE SAUCE

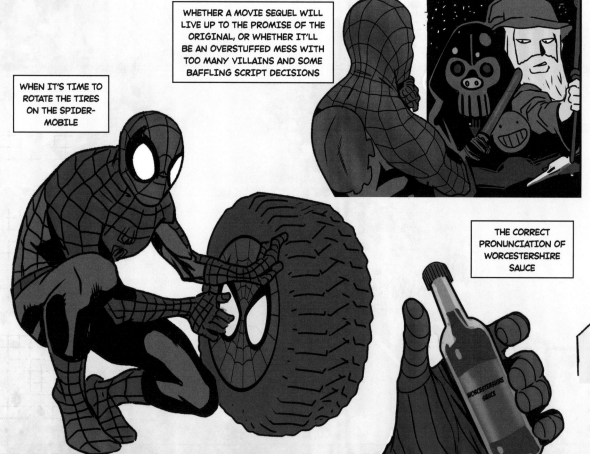

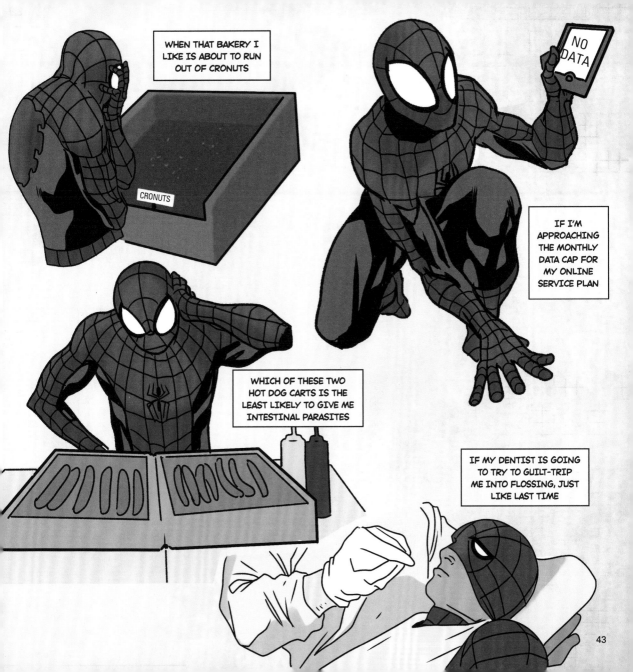

HOW TO KEEP A SECRET IDENTITY

YOU WERE PROBABLY A REGULAR PERSON before you got super powers, so why mess with a good thing? A secret identity lets you have the best of both worlds, but it comes with twice the headaches.

Reasons why you might want to have a secret identity:
- To just chill out once in a while without people constantly nagging you about fighting the lava monsters
- To protect your loved ones from grudge-carrying Super Villains
- To blow everybody's mind when you do a dramatic unmasking
- To duck personal-injury lawyers and insurance adjusters because of that time you put the Purple Man in a neck brace while trashing Grand Central Terminal

HOW TO KEEP YOUR SECRET IDENTITY SECURE:

Your Super Hero **MASK**: If it doesn't cover your entire face (like mine), then don't grow an old-timey 1890s baseball mustache.

Don't just put on a pair of **GLASSES** and call it a day. Despite popular opinion, glasses don't actually change the shape of the human face.

Avoid doing the "Who, me?" Don't dress in clothes that are the **SAME COLORS** as your Super Hero costume. Don't wear a lapel pin in the shape of your heroic insignia. And if somebody asks whether a Super Hero is nearby, don't answer, "Closer than you think, friend, closer than you think" while winking.

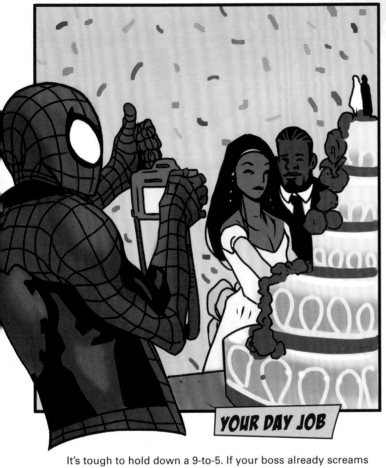

YOUR DAY JOB

It's tough to hold down a 9-to-5. If your boss already screams at you when you sneak in a game of Sudoku, imagine what will happen when you disappear at 3 o'clock on a Friday afternoon. In an office environment, "fighting stampeding dinosaurs in the Savage Land" isn't a legitimate excuse. Instead, you can try freelancing, like me!

PRO: You set your own hours.
CON: You've got to hustle if you want to line up jobs.

By the way, did you know I also photograph weddings? Tell your friends!

IF YOUR SECRET IDENTITY IS COMPROMISED:

Initiate **DAMAGE CONTROL**: You've never heard of that Super Hero, you were never at the scene of that miraculous escalator rescue, *no hablo inglés*.

Persuade **DOCTOR STRANGE** to drop a mind-control whammy on everyone in the city, giving them selective amnesia.

Do a disappearing act:
- **HUM A TUNE** that sounds vaguely like your ringtone.
- Say, "I've really gotta take this."
- Run away and never return.

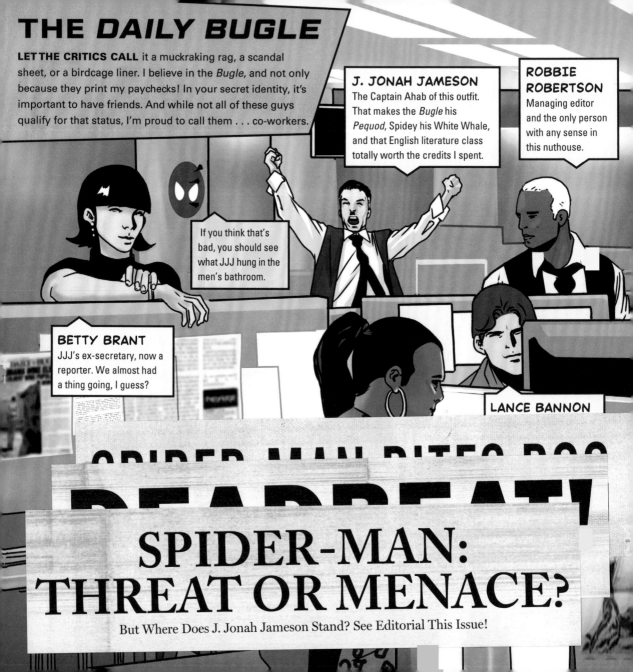

THE DAILY BUGLE

LET THE CRITICS CALL it a muckraking rag, a scandal sheet, or a birdcage liner. I believe in the *Bugle*, and not only because they print my paychecks! In your secret identity, it's important to have friends. And while not all of these guys qualify for that status, I'm proud to call them . . . co-workers.

J. JONAH JAMESON
The Captain Ahab of this outfit. That makes the *Bugle* his *Pequod*, Spidey his White Whale, and that English literature class totally worth the credits I spent.

ROBBIE ROBERTSON
Managing editor and the only person with any sense in this nuthouse.

If you think that's bad, you should see what JJJ hung in the men's bathroom.

BETTY BRANT
JJJ's ex-secretary, now a reporter. We almost had a thing going, I guess?

LANCE BANNON

SPIDER-MAN BITES DOG

DEADBEAT!

SPIDER-MAN: THREAT OR MENACE?

But Where Does J. Jonah Jameson Stand? See Editorial This Issue!

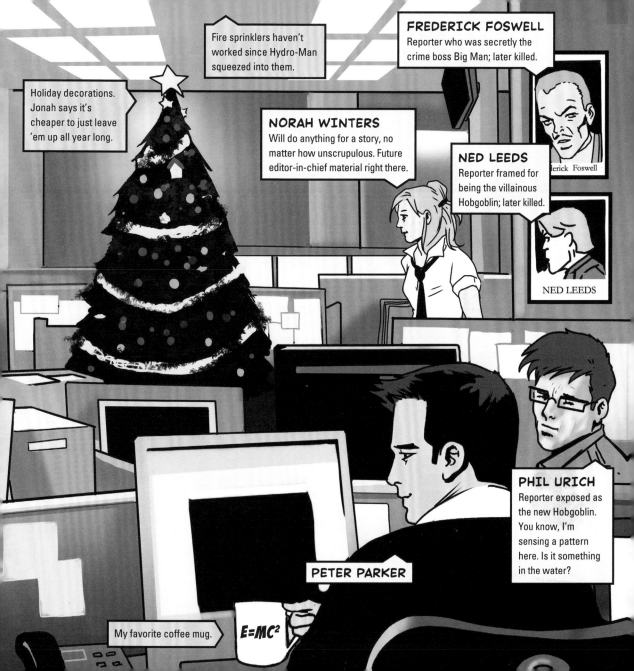

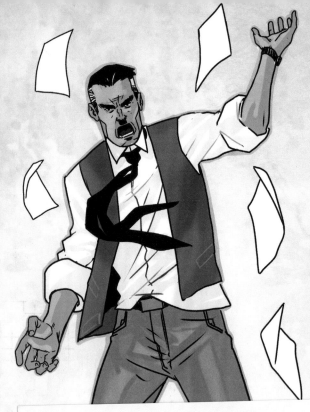

THINK YOUR BOSS IS BAD?

I KNOW THINGS ARE TOUGH all over. You need a job, and you've got to take what you can get, unless you were born into Osborn money. But before you complain, I bet you a MetroCard that your boss can't hold a candle to ol' Flat-Top.

J. JONAH JAMESON'S TEN WORST CRIMES AGAINST WORKING STIFFS

1. Held weekend brainstorming session to come up with the most inflammatory Spider-Man headline; prize was not getting fired.

2. To combat declining print sales, started rumor that computer screens give off gamma radiation.

3. Once threw an intern out of a window for wearing a Red Sox cap. (It was only a second-story window, but still.)

4. Company healthcare plan is a plastic bandage, two aspirins, and a card reading "Suck it up, junior."

5. Company fitness plan: refusing to fix the elevator.

6. Makes new employees coat the ledge outside his window with anti-stick, anti-spider spray.

7. Christmas bonus: a second pot of coffee.

8. Canceled Casual Fridays because "That's just what Spider-Man would be expecting us to do."

9. On rainy days, forces staffers to sell yesterday's *Bugle* copies as umbrellas.

10. Sends secretary on semi-weekly shopping runs for mustache wax and new paperweights for throwing at interns.

J. Jonah Jameson
Publisher
Editor-in-Chief
Generalissimo

DAILY BUGLE®

736 2nd Ave.
New York, NY 10016

Office: (212) 555-7201
Email: Don't you dare!

HOW DOES PETER GET THOSE SHOTS OF SPIDER-MAN?

MY BOSS MIGHT BE a skinflint, but I still make rent every month. How? Pictures of Spider-Man!

Jolly Jonah hates Spidey, but the *Bugle* moves copies every time he puts a story about me on the front page. And front-page stories need photos! That's where I come in, and it's how I've been able to scratch out a living in a city where a hot dog will set you back five bucks. If your heroic alter ego gets sufficiently famous—or at least notorious—you can make your own publicity . . . and capitalize on it, too!

What's my secret? A motion-tracking camera with automatic zoom and a smart shutter.

FOLLOW THESE STEPS

STEP 1: Affix the camera to a building ledge using webbing or a similar adhesive. Make sure your camera has an elevated view of the city blocks below.

STEP 2: Check the camera to make sure it's fully charged and has plenty of storage capacity.

STEP 3: Activate the camera's auto-trackers and swing into action, hero!

STEP 4: Return to pick up the camera at the end of your shift.

While you're out doing your patrols, don't forget to strut your stuff in front of the camera for some nice hero images. An even better strategy is to lure your enemies within camera range. Media outlets pay big bucks for action shots!

WHERE DO THE CLOTHES GO?

WHEN YOU MAINTAIN A SECRET IDENTITY, you need to keep your costume close. I mean really close. Underwear close.

Your costume is probably skin-tight, anyway *[FOOTNOTE: If it isn't, oh spiky-armored one, might I suggest you read Tony Stark's book instead?]*, so this situation really isn't all that bad. Especially when you're patrolling at night, or in the rain, or at Christmas, or when a taxi cuts too close to the curb and kicks slushy spray all over your shins. Think of your costume like a snuggly layer of thermal insulation, and you're the faithful postman! And if it's the middle of August, try not to think of it at all!

So whenever you need to go a-heroing, you'll have to strip off your outer clothing layer to reveal the costume beneath. No problem, you've seen it done a hundred times in the movies. But then what happens to your daily wear? You don't have a black AmEx card, which means you can't afford to buy an all-new outfit every time duty calls. *[FOOTNOTE: And if you do have a black AmEx card, you really, really need to be reading Tony Stark's book instead. Can't emphasize this enough.]*

HERE'S WHAT I DO: Bundle up everything, protect it with a sheath of waterproof webbing, and stick the bundle in some out-of-the-way spot. The corner of an alleyway. The wall of a loading dock. Inside the Guggenheim Museum. (Seriously, nobody says anything! You'd be surprised what you can leave in there!)

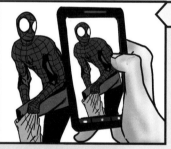

STEP 1:

Make sure nobody's around before you change, chucklehead! Smartphones are your worst enemy. No, don't use a phone booth! Where would you even find a phone booth?

STEP 2:

Wallet and phone go inside your shoes, shoes go inside your pants, pants go inside your shirt, belt gets cinched around the whole thing.

STEP 3:

Web it up! Nice and sticky.

STEP 4:

Find your spot. Stick the bundle. Don't forget to come back.

I've been using this method for years. Sometimes it backfires. I never said it was foolproof.

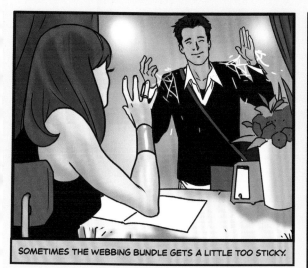

SOMETIMES THE WEBBING BUNDLE GETS A LITTLE TOO STICKY.

ONCE IN A WHILE I FORGET ABOUT A BUNDLE. FOR, LIKE, A LONG TIME. NOSTALGIA TIME-CAPSULE LONG.

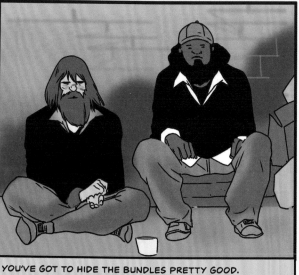

YOU'VE GOT TO HIDE THE BUNDLES PRETTY GOOD. OTHERWISE, FREE CLOTHES!

I'M NOT THE ONLY ONE WHO DOES THIS.

SCIENCE!

THERE'S NOTHING I LIKE MORE! CHEMISTRY, BIOLOGY, PHYSICS ... SCIENCE TELLS US HOW THE WORLD WORKS—AND IN THE HERO BIZ, IT PAYS TO BE PREPARED.

TO EXPLAIN SOME OF THE MOST CUTTING-EDGE THEORIES IN SCIENCE, HERE'S DR. REED RICHARDS OF THE FANTASTIC FOUR! HOW ARE YOU TODAY, DR. RICHARDS?

I'M ... FANTASTIC, PETER! THESE FIELDS OF STUDY HAVE BEEN IGNORED BY MY PEERS AT MIT AS FRINGE SCIENCE, BUT I HAVE FOUND THEM TO OCCUR WITH GREAT FREQUENCY WITHIN THE SUPER HERO COMMUNITY!

HORIZON LABS QUICK-REFERENCE CARDS

SO YOU'VE BECOME UNSTUCK IN TIME

SO YOU'RE ON AN UNFAMILIAR PLANET

LEE'S UNCERTAINTY PRINCIPLE

Exposing the human body to radiation will trigger utterly random but largely beneficial effects. If you try to replicate those same effects under controlled laboratory conditions, you will suffer a tragic, ironic fate under the Karmic Corollary.

SPIDER-MAN

MAN-SPIDER

THEMATIC PREDESTINATION

Don't get born with a bad name, like Victor von Doom or Addison McEvil. What were your parents thinking? It's already too late!

LIKELIHOOD OF SUPER VILLAINY: 87.9%

ALLITERATIVE APPELLATION AXIOM

People who have the same initials in both their first and last names score unusually high on the Heroic Propensity Scale. Why, just look at our monograms!

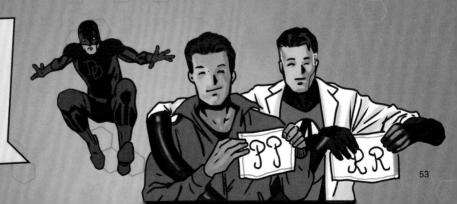

JUGGLING YOUR LOVE LIFE

WAIT, WHY ARE YOU coming to me for dating advice? I'm a Super Hero, not some costumed Casanova. Although I guess there was that one time, and if you count her, and then she and I once had a thing going, and . . . you know what? I guess I have had some success in the romance department. Well played, reader, well played.

I can tell you it's tough to balance your regular life, your heroing life, *and* your love life. But here's a few things to keep in mind. **Find the Right Fit!** Maybe it will work, maybe it won't. Look, I don't have the best track record, all right?

MARY JANE WATSON

Model and actress. Way better looking than me and twice as talented. Calls me "Tiger."

WHY IT DIDN'T WORK:
You tell me! Sometimes I feel like we could have gotten married! And spent, I dunno, twenty years together! But then I wake up.

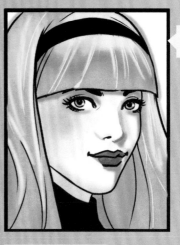

GWEN STACY

Biochemistry student at ESU. Had a great heart and always stuck up for the little people.

WHY IT DIDN'T WORK:
Green Goblin. Bridge. Not going to talk about it.

FELICIA HARDY (THE BLACK CAT)

She found the right costume to match her personality, that's for sure. Felicia is a cat burglar (I try to stop her, honest), she has scratchy kitty claws, and she likes to curl up in puddles of sunlight.

WHY IT DIDN'T WORK:
I'm a hero, she's a villain! These sorts of "wrong side of the tracks" romances aren't uncommon in this biz, but you can expect them to quickly fizzle.

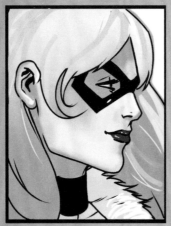

CARLIE COOPER

NYPD detective and forensics expert. She also skates on a roller derby team, and her shoulder-check could knock the Rhino on his butt.

WHY IT DIDN'T WORK:
Did I mention she's a police detective? Carlie kind of . . . deduced my Super Hero identity before I had a chance to tell her myself. (Note: "I was going to get around to it sooner or later" isn't a valid excuse.)

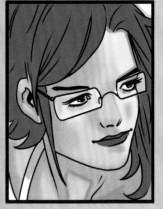

TO TELL OR NOT TO TELL?

There are good reasons for keeping your secret identity a secret—even when it means hiding your true self from a committed partner in a long-term relationship. Don't give me that look, I'm serious!

- **GOOD REASON**: Crazed, mutated abomination has vowed to exterminate everyone you care about
- **NOT A GOOD REASON**: Because the whole thing has gone on so long that revealing the truth would just be awkward at this point

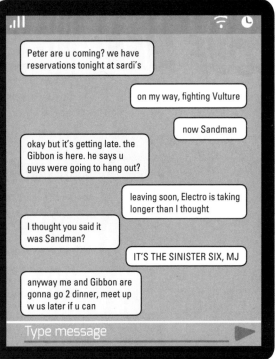

THE WACKY DATE

Oh, it's gonna happen! If your partner doesn't know your secret, a Super Villain is sure to raid the restaurant the instant the waiter brings your menus. No worries! Excuse yourself, collar the crook, and return to your table as quickly as you can. Your date will never know!

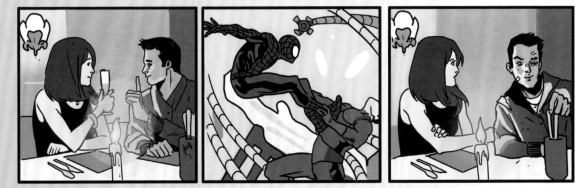

SO YOU WANT TO BE AN AVENGER?

I DON'T BLAME YOU, they're the biggest game in town. I mean there's also the X-Men, but they only accept mutants and—hang on, is that even legal? Your friendly neighborhood Spider-Man has served on the Avengers once or twice, and so can you! Here's what you need to know before tryouts.

CAPTAIN AMERICA

This star-spangled Avenger once socked Hitler in the jaw.

LIKES: People who still say "yes, sir" and "yes, ma'am"

DISLIKES: That the Brooklyn Dodgers moved to L.A. in 1957

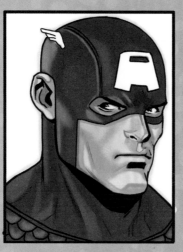

THOR

Dreamy Asgardian Thunder God. You'd have arms like that, too, if you carried an enormous hammer with you 24/7.

LIKES: Learning English from Shakespeare in the Park, apparently

DISLIKES: Frost Giants

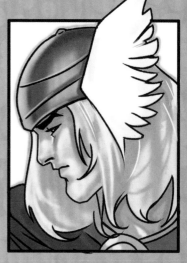

IRON MAN

What if Thomas Edison built jet-powered battlesuits? That's this guy right here.

LIKES: Parties

DISLIKES: Bending down to pick up $100 bills. Did you know that by taking time out of his day to do that, he'd actually *lose* money?

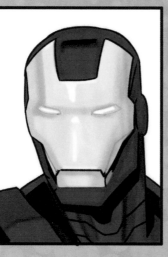

HULK

Gamma-irradiated, two-legged tank with a bowl cut

LIKES: Smashy smashy

DISLIKES: Counting higher than three

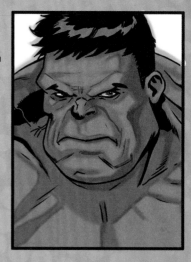

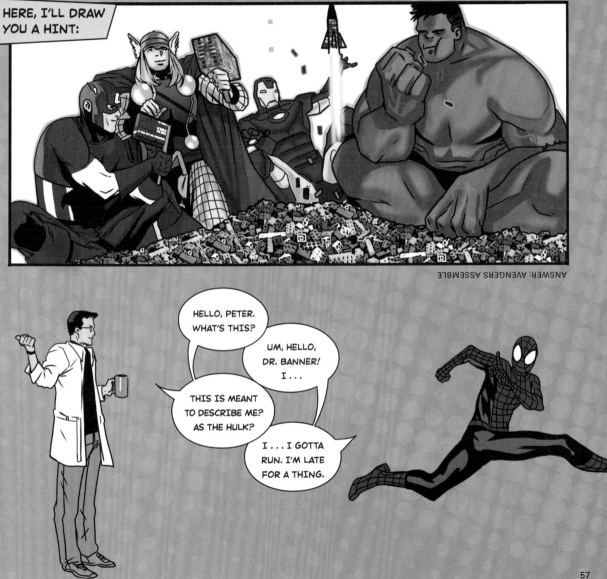

FINALLY, HAVE YOU MEMORIZED THE TEAM'S BATTLE CRY?

HERE, I'LL DRAW YOU A HINT:

ANSWER: AVENGERS ASSEMBLE

HELLO, PETER. WHAT'S THIS?

UM, HELLO, DR. BANNER! I...

THIS IS MEANT TO DESCRIBE ME? AS THE HULK?

I... I GOTTA RUN. I'M LATE FOR A THING.

Oh my stars! Here I have the opportunity to write in my nephew Peter's book, and I'm just pleased as punch. I have some special things to share, as long as Peter doesn't mind! I brought out the old family scrapbooks, and if you're hungry I'll let you in on the recipe for my famous ~~~ ... have a ~

Aunt May's Tummy-Tickling Wheatcakes
~ A Parker Family Tradition ~

- 1 cup buckwheat flour
- 1 cup sifted whole wheat flour
- 2 teaspoons double-acting baking powder
- 1 teaspoon baking soda
- 1 teaspoon salt

♥ *Turn over for secret ingredient!*

In a separate bowl, mix 2 cups buttermilk and 2 teaspoons molasses, then set aside.

Add to the flour mix:
- 2 beaten eggs
- 1/4 cup melted butter
- Buttermilk/molasses mixture

Whip 2 egg whites until stiff (but not dry!), then fold them into the batter gently until blended. Don't overmix! Cook on a greased hot griddle or frying pan until small bubbles appear on top. Turn pancakes over and cook until bottom is lightly browned. Serve hot, with butter and maple

Peter's friend Flash helps him find his house keys.

Peter's big present—a calculator watch! Happy sixteenth!

I help Peter pick his outfit for the first day of school.

Peter didn't have a date to the spring formal, so we had a celebration of our own! Such fun!

e Club.

That's right, punk: shapeshifting! You can make tendrils, and spiky things, and bulk yourself up without hitting the gym. I think the fangs are poison or something, I dunno. Maybe bite something with 'em? Don't forget the drool. And give it lots of tongue! Don't ask me why ya gotta, ya just gotta!

GUEST SECTION, BY VENOM

SEE THAT BLACK STRIP on the edge of the page? Did ya touch it? Congrats, fresh meat! You're now infected by an alien symbiote.

Yeah, an alien. And not the "take me to your leader" kind. I'm talking the tear-your-heart-out, "comics ain't for kids anymore" kind. Like me. I'm an anti-hero!

The symbiote is also your costume, see? It forms around your skin, and you can shape it however ya want.

RESTING CONFIGURATION

ACTION CONFIGURATION

SUNDAY FOOTBALL CONFIGURATION

You're a host for a symbiote now, so ya might start referring to yourself in the third person. Or maybe not, it comes and goes. But here's a few phrases to get ya started on your way to becoming a nasty piece o' work!

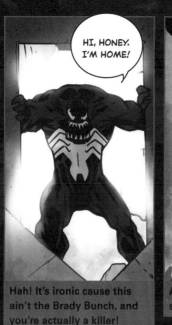

HI, HONEY. I'M HOME!

Hah! It's ironic cause this ain't the Brady Bunch, and you're actually a killer!

YOU CAN RUN, MEAT, BUT YOU CAN'T HIDE!

A classic. Keeps your prey sweating!

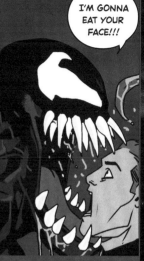

I'M GONNA EAT YOUR FACE!!!

A little advanced. Don't launch with this on Day One.

WEAKNESSES

Yeah, you've got one—**sonic vibrations**. Keep your distance from:

- Car alarms
- Grandfather clocks
- Holiday renditions of "Carol of the Bells"
- Those little ringy things on tricycles— better safe than sorry
- Big Ben

QUIZ: ARE YOU READY TO BE A SUPER HERO?

OKAY, TIME TO SHOW ME what you've learned! If you answer these questions honestly, you'll find out if you've got what it takes to be the next friendly neighborhood Spider-Man. Don't blame me if you don't like the results! This is an advice book, not a self-improvement seminar!

Your worst habit is:
A: Always borrowing pens and forgetting to return them
B: Showing up late for work because so many kittens needed help getting down from trees
C: Robbing banks before 9 a.m. on a Saturday

For your eighth grade science fair exhibit, you made:
A: A potato clock
B: A revolutionary new form of energy that will never be reproduced by anyone else ever
C: A fully armed and operational death ray

Your nickname is:
A: " . . . who?"
B: "Savior of the Universe"
C: "Our Dark Overlord"

You've been bitten by a radioactive hedgehog. You . . .
A: Apply antibacterial cream and a plastic bandage
B: Acquire a hedgehog costume and a Hedgehog-Mobile
C: Acquire a hedgehog costume and a Hedgehog-Mobile, but with a dark color scheme

Your most prized possession is:
A: That snow globe from your trip to Mount Rushmore
B: A thank-you letter from the time you saved Mrs. Blanchard's kindergarten class
C: That snow globe containing the actual Mount Rushmore after you miniaturized it with a shrink ray

A group of Super Villains has hijacked a weather satellite and plans to hold the world hostage. Your reaction is:

A: "Those awful people! Well, time to look at cat videos."
B: "Those awful people! To the Quinjet!"
C: "Those awful people! Are they hiring?"

A good entry-level job in today's economy is:

A: Intern
B: Sidekick
C: Henchman

Your enemies have teamed up to defeat you. They call themselves:

A: The human resources department
B: The Sinister Horde of Evildoers
C: The Champions of Virtue

What does "saving the earth" mean to you?

A: Swapping out your regular bulbs for fluorescent ones
B: Shutting down that doomsday device in the nick of time
C: Putting Earth last on your list of planets to conquer after Jupiter, Venus, and Saturn

The newspaper revealed your secret identity. You:

A: Say, "Well, it had to happen sometime. At least I had a nice run."
B: Use your robot duplicate to get photographed in two places at once, raising public doubts
C: Vaporize the newspaper building

A giant robot is heading straight for you! You:

A: Eat more popcorn—you paid for this movie, so you're getting your money's worth
B: Blast the robot's eyes to blind it and then trip up its legs
C: Retreat while shouting "Curse you!" and shaking your fist

RESULTS

Add up the number of A, B, and C answers you selected and check your results below.

MOSTLY A: You're . . . nice. No really, you're one of the good ones. You're just not hero material, you know? Aww, don't be like that. Maybe we can get coffee sometime?

MOSTLY B: Nice! Up high, hero buddy! You've got the goods, so I expect to see you out on patrol soon. Just don't fight crime on my turf, you know? We Super Heroes have a really complicated concept of jurisdiction.

MOSTLY C: Don't get me wrong, I'm glad you bought my book, but maybe something by Doc Ock would have been more your speed? You're pretty much a Super Villain, so the Avengers are on their way to your current location. When you get out of prison in Ryker's Island we'll fight or something. Until then, keep smiling!

INSIGHT EDITIONS

PO Box 3088
San Rafael, CA 94912
www.insighteditions.com

Find us on Facebook: www.facebook.com/InsightEditions
Follow us on Twitter: @insighteditions

marvel.com
© 2014 MARVEL

All rights reserved.

Published by Insight Editions, San Rafael, California, in 2014.
No part of this book may be reproduced in any form without
written permission from the publisher.

Library of Congress Cataloging-in-Publication Data available.

ISBN: 978-1-60887-394-4

ROOTS of PEACE REPLANTED PAPER

Insight Editions, in association with Roots of Peace, will plant two trees
for each tree used in the manufacturing of this book. Roots of Peace is an
internationally renowned humanitarian organization dedicated to eradicating
land mines worldwide and converting war-torn lands into productive farms
and wildlife habitats. Roots of Peace will plant two million fruit and nut trees in
Afghanistan and provide farmers there with the skills and support necessary
for sustainable land use.

Manufactured in Hong Kong by Insight Editions

10 9 8 7 6 5 4 3 2 1

ABOUT THE INSIGHT LEGENDS SERIES

Insight Legends is a collectible pop culture library featuring books that take an in-depth look at iconic characters and other elements from the worlds of comics, movies, and video games. Packed with special items that give the books an immersive, interactive feel, the series delivers unparalleled insight into the best-loved characters in popular culture and the worlds they inhabit.

PUBLISHER Raoul Goff
EDITOR Chris Prince
ACQUISITIONS EDITOR Robbie Schmidt
ART DIRECTOR Chrissy Kwasnik
INTERIOR DESIGN & LAYOUT Jenelle Wagner
PRODUCTION MANAGER Anna Wan
PRODUCTION EDITOR Rachel Anderson
EDITORIAL ASSISTANT Elaine Ou

WRITTEN BY Daniel Wallace
ILLUSTRATED BY Mirco Pierfederici

INSIGHT EDITIONS would like to thank
David Gabriel, Mark Annunziato, Daniel Saeva,
Curt Baker, Tomas Palacios, Jeff Youngquist,
Sarah Brunstad, Brian Overton, Mike Fichera,
and Mike O'Sullivan.